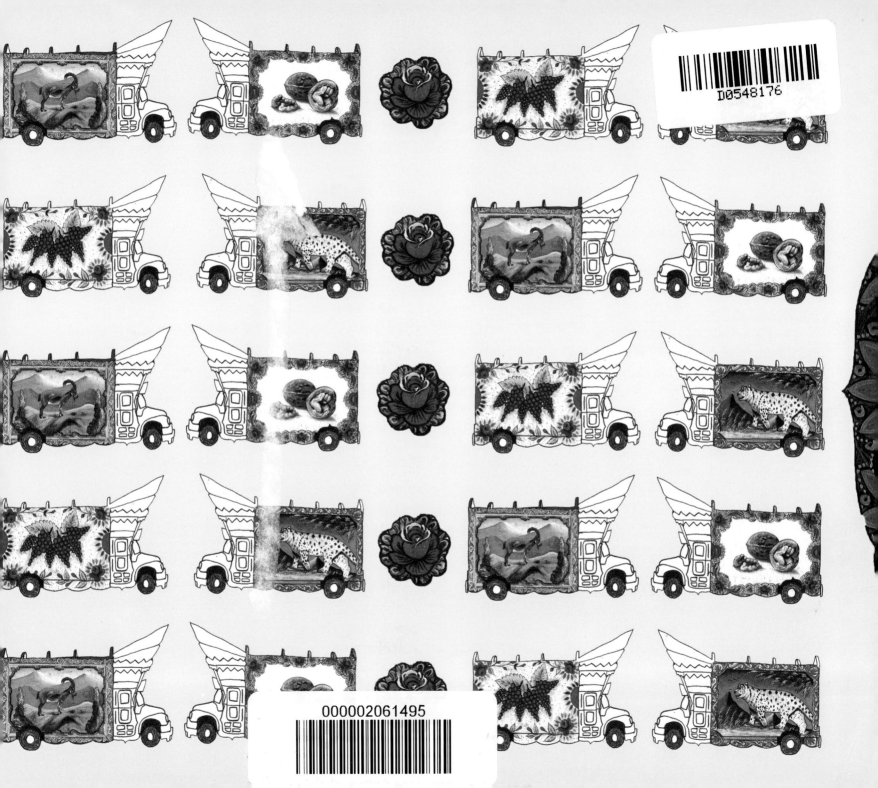

This Truck has Got to be
Special

Text: **Anjum Rana**

Illustration Design: **Sameer Kulavoor**
Truck Art: **Hakeem Nawaz and Amer Khan**

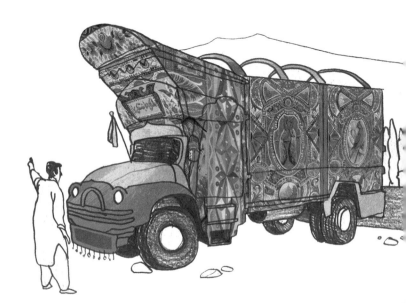

My name is Chinar Gul.

I am from the Swat Valley in the north of Pakistan, where it snows in winter and stays cool in summer. As you go down the slopes of the Hindu Kush towards Malakand and Charsadda, it gets warmer and turns very hot in the summer months. During this time many tourists visit Swat – for their summer vacations. In winter, they go to Malam Jabba to ski. Some people come here to see old Buddhist sites.

Today, I am at a truck-yard in Taxila, over two hundred miles south of my home village. I have come to get my truck painted. Two days ago, I paid off the last instalment on the loan I'd taken to buy this truck. I have driven it for over 5 years, and today it's mine. After 30 years of being on the road, I have my own truck, and want it painted in bright, welcoming colours. Zarrar, the artist, is my friend. He has painted the trucks I drove earlier. But he did this according to the instructions of men who owned the trucks. I liked some designs, didn't like others. It's very exciting to think that I can paint my truck the way I want.

When I first started to drive, I was not sure what anyone got out of painting a truck. But having seen so many trucks, all so beautifully decorated, I realise it's like getting your house done up. It makes it welcoming and your own. A painted truck is like a decorated bride who is waiting for you at home.

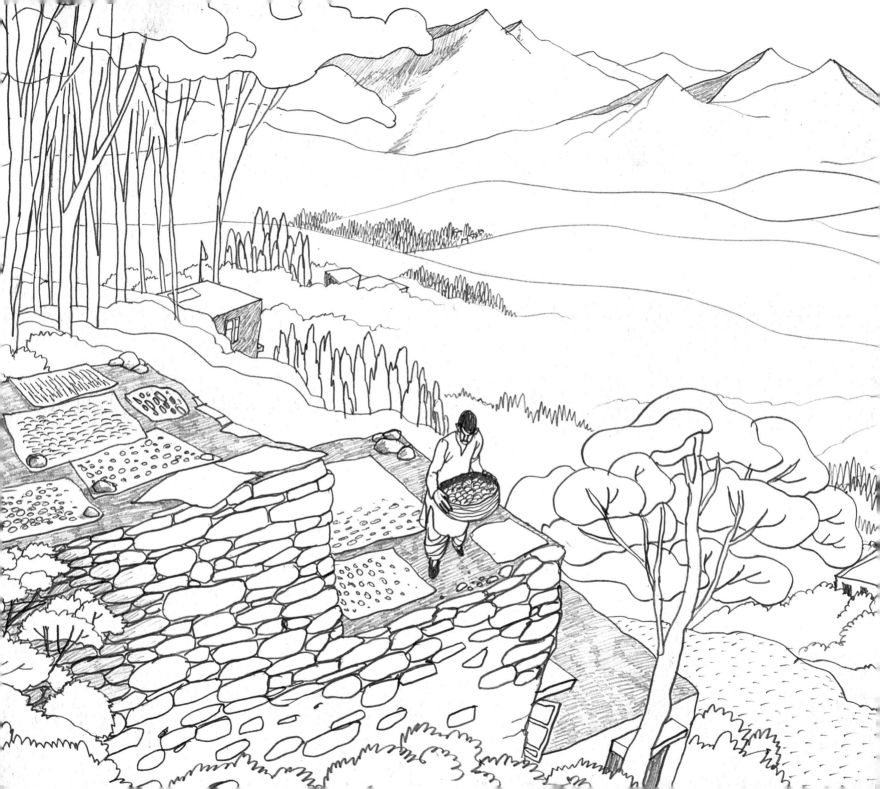

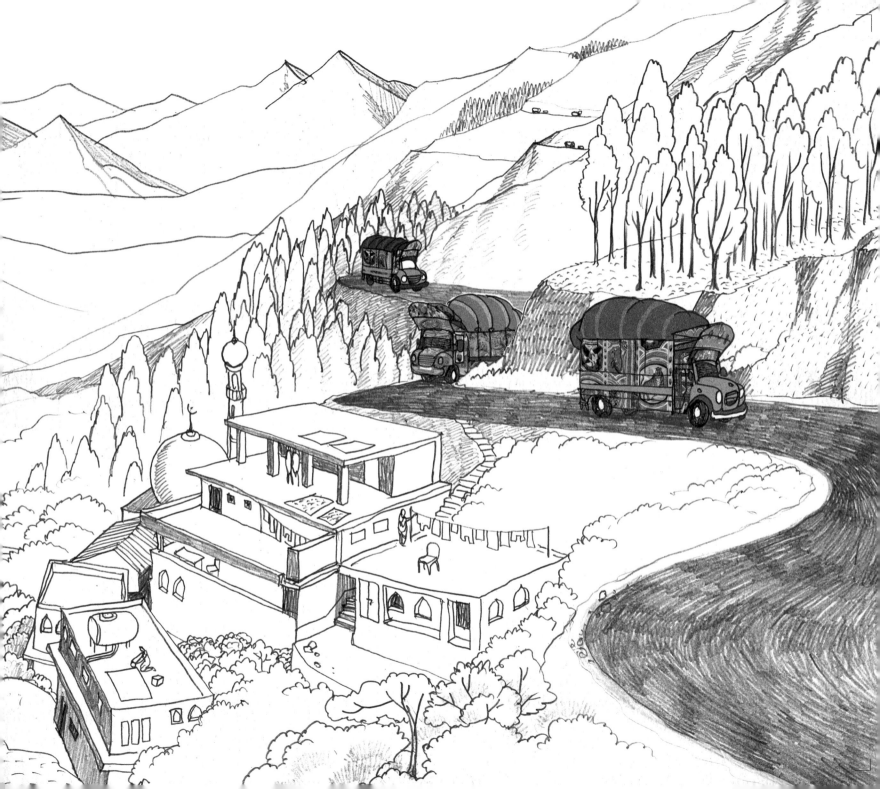

I still remember the truck I was on first, as a cleaner.

I did the route from Swat to Peshawar. The truck was part of a large fleet of 34 vehicles, going in different directions. It was beautiful, with a large 'Taj' – that's what we call the image painted above the windshield. That richly decorated image is fresh in my mind like a photo: the Taj Mahal in the middle, with peacocks on the sides. Back then, my job was to clean the truck wherever it stopped – a 'cleander', as they say in my language. That's who I was!

I'd not been to school, we were poor and I needed to help the family. At first it felt scary, to be away from home for weeks on end. My mother would pack dried walnuts, almonds, mulberries and apricots in a pillow case. This was my staple diet during those long first trips. This pillow packet also reminded me of home, and helped me cope with homesickness. For these were fruit from our fields. They are dried in the summer months and eaten when there is nothing else to eat. Nowadays when I am on a long trip and feel homesick, I make up sad poetry, which reminds me of my loved ones.

By and by the mountain roads became familiar spaces. I was also less and less afraid. But it took me a while to get used to being on the road for hours without sleep and food. Many days I ate only roti and dal as everything else was too expensive. Today I can afford the occasional mutton and chicken, but not when I started work and I was only a cleander.

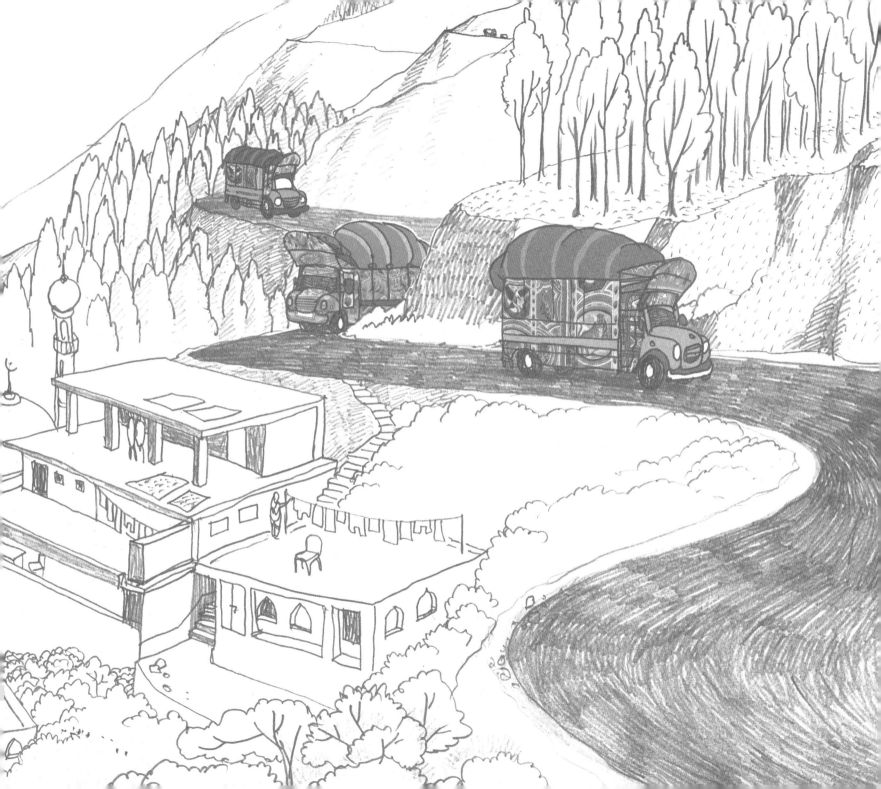

I know the mountain roads so well, each bend where the water is sweet, and there is a welcoming dhaba...

Oh, here is Zarrar: he is ready to start the paint work, he says. I know all the painting steps. First, they scrape off what's on the old rusty truck – especially the rust – and then apply a primer. Some truck owners go for a completely new look: they ask for the truck to be stripped down to its essentials. All you see then is the chassis, wheels, and pieces of wood or steel. Some truck owners have new wooden side panels made after a few years.

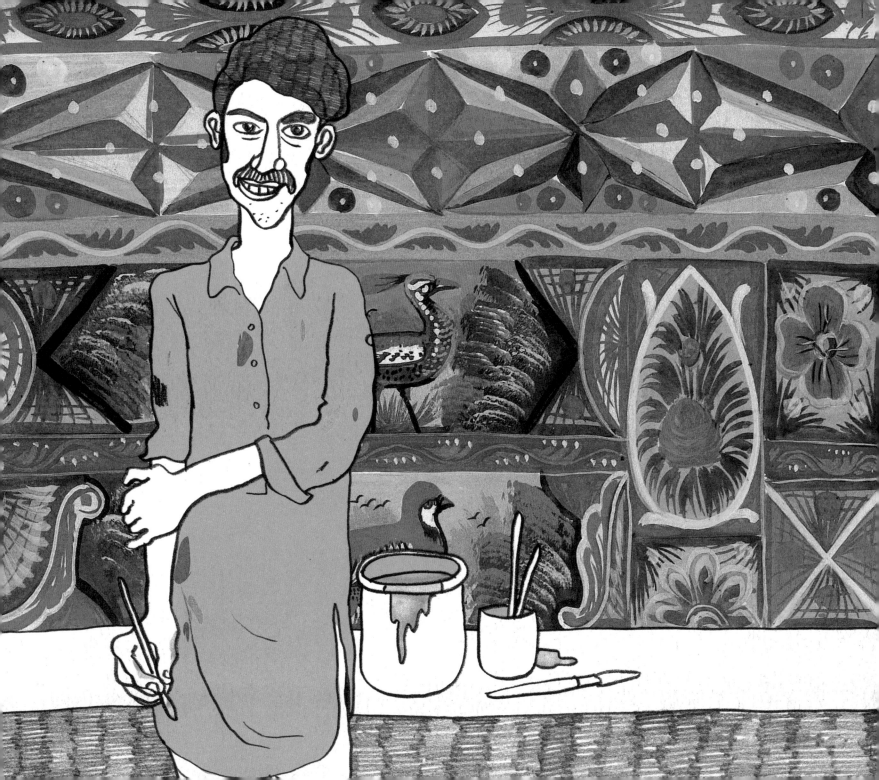

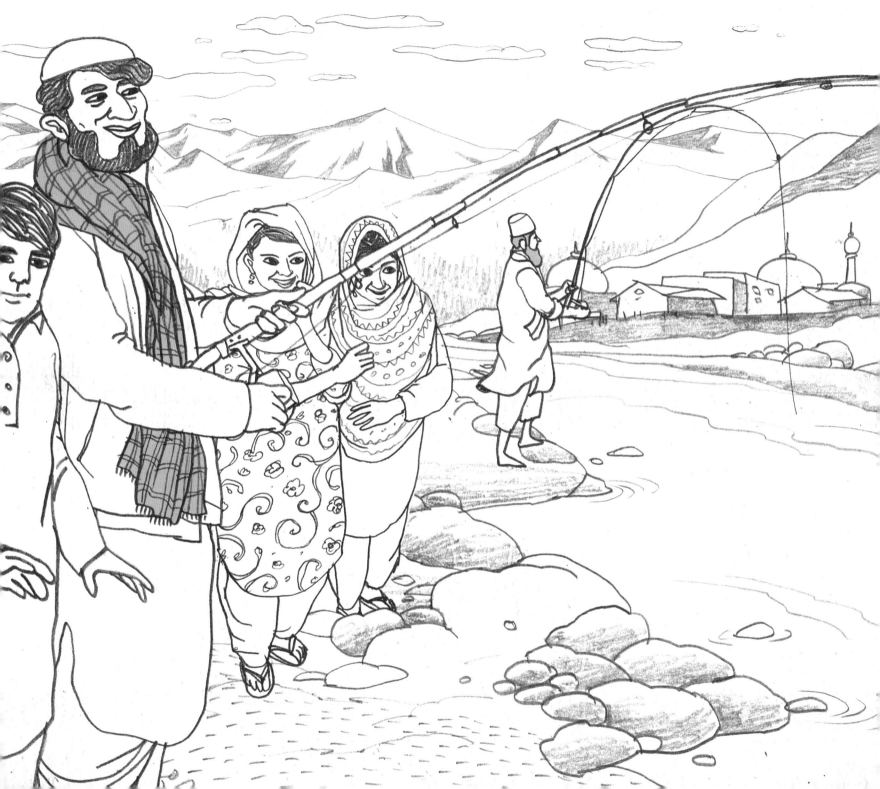

I can't remember the exact year I started to drive.

I thought I'd never stop being a cleander, but when I was old enough to drive, I was asked by the truck-owner, my boss, to get a licence and take to the road. That was not a mountain road, but the Grand Trunk Road, which as you know, runs all the way from Karachi in the south to Kabul in the north-west. I had been on this road several times as a cleander and then found myself driving down it!

Suddenly, everything seemed new. Crossing the Sind, which is dry and dusty, into the Punjab, though I've done it many times, felt different now. The lush green everywhere, especially of the mangoes – that colour stayed with me on that trip. Driving through the Punjab right upto Peshawar, I followed the green. In winter this landscape changes – then there are oranges, peeping out of dark green leaves. The farmers offer us fruits, whatever is in season and also sell them along the highway.

Alongside the Grand Trunk Road flows the Kabul River. I like to fish in it – I've done river-fishing in Swat, where we fish rainbow trout. But in the Kabul River, you find big river fish.

The river is a sight to behold. For a couple of hours, road and river run together. It is a lovely cool drive with tall trees on both sides of the road. At one point the Kabul River meets the River Indus, and that is a startling sight. The colours of the two rivers are so different yet they merge and there you have the mighty Indus.

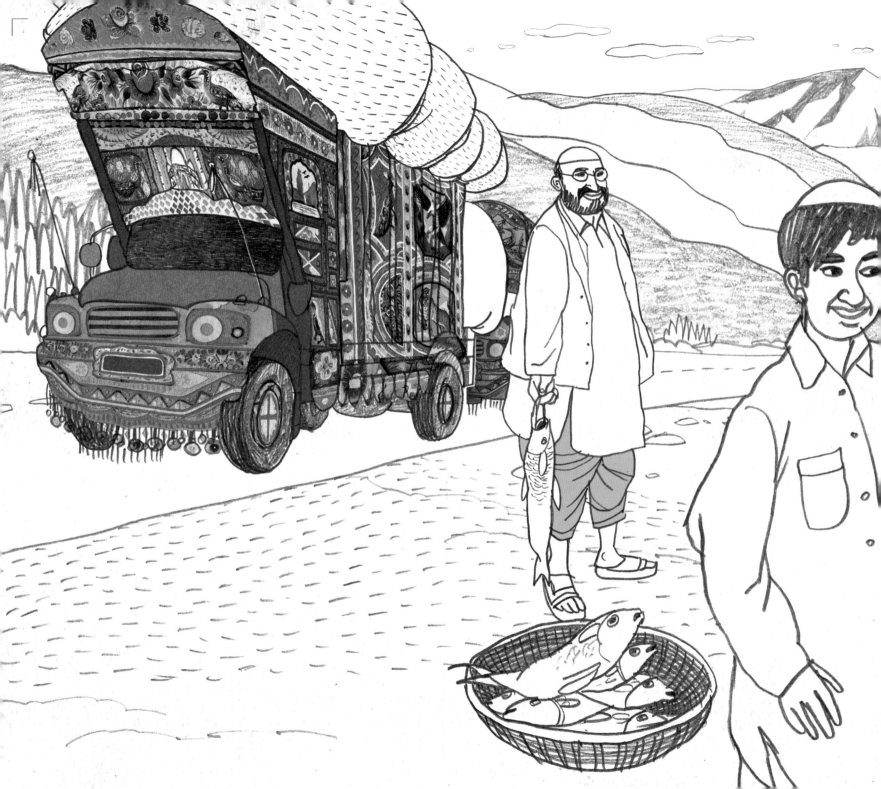

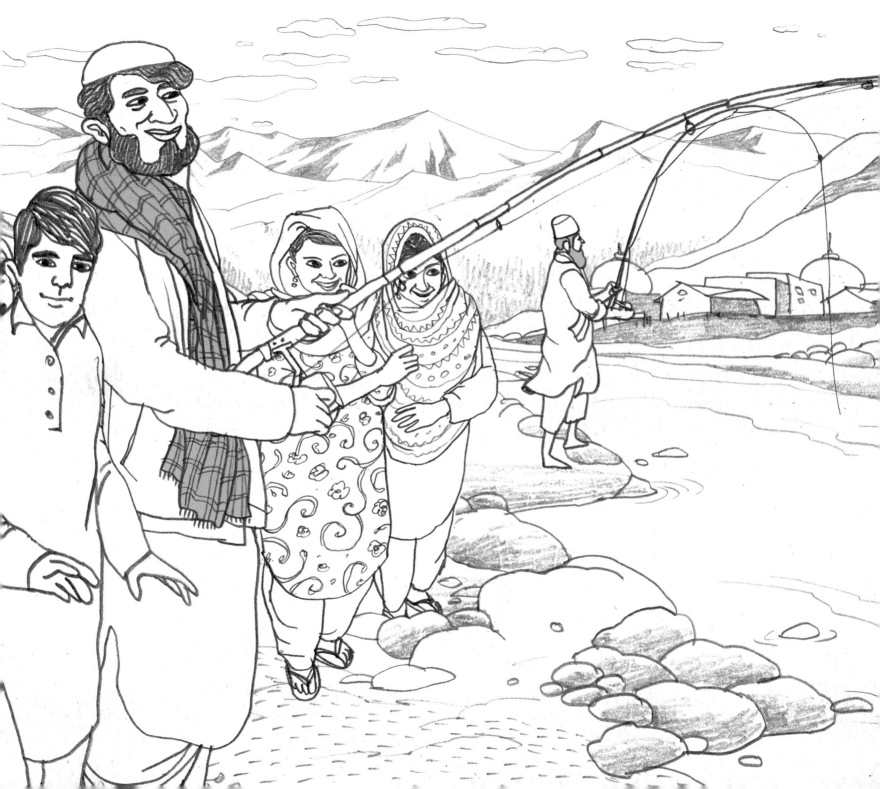

"This truck's got to be special," says Zarrar.

I am happy to be interrupted in my thoughts and agree with what he says. Not every driver gets to own a truck. For many of us, it's a dream of a lifetime. I thank God that my dream came true.

"I'm not looking at old designs for this," Zarrar assures me. He shows me the reference drawing book he carries with him, and flips through it rapidly. "I'm doing free-style, from the designs in my head."

I guess this is why I chose him to paint my truck, though I've known other painters. There is Ajab, a man from Peshawar. He was 12, when his father let him fill dots with colour on the side panel of a truck. He also learned to mix paint, wash brushes, and put up the scaffold that painters climb on to paint upper parts of the truck. He wanted to draw, but had to wait for more than a year to sketch his first bird. When it comes to painting a truck, either you learned everything or nothing. If I remember right, it was nearly 15 years before Ajab could claim to be a truck-painting 'ustaad' or maestro. It's the same with Zarrar. He started out very young, but look at him today! He has all kinds of designs in his head and assistants, also known as 'chottas', who follow his instructions. I can't wait for him to start painting.

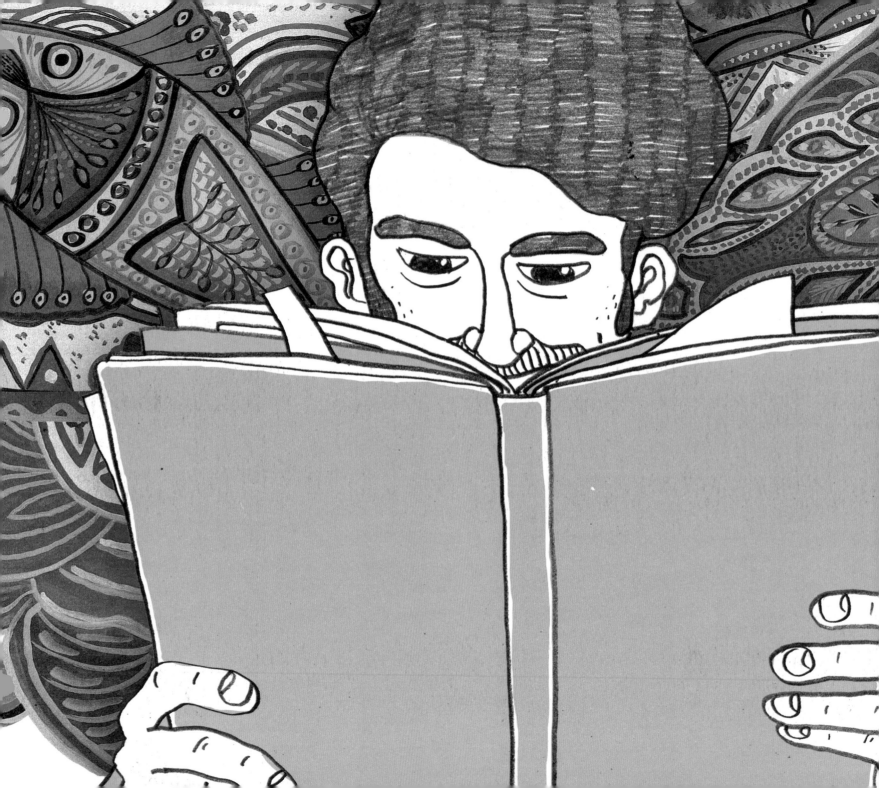

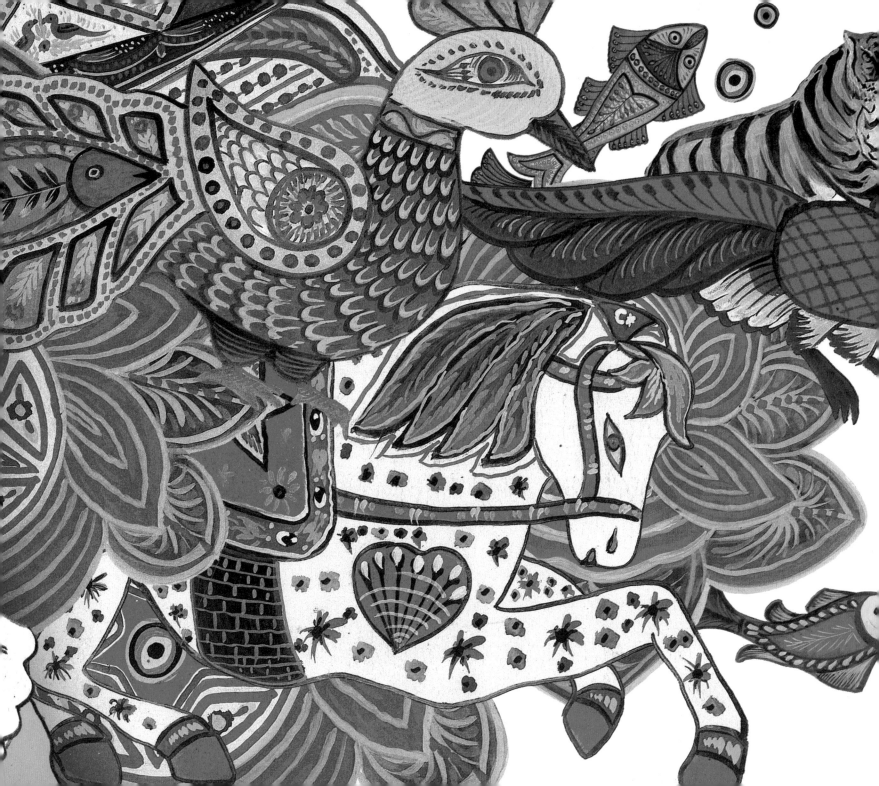

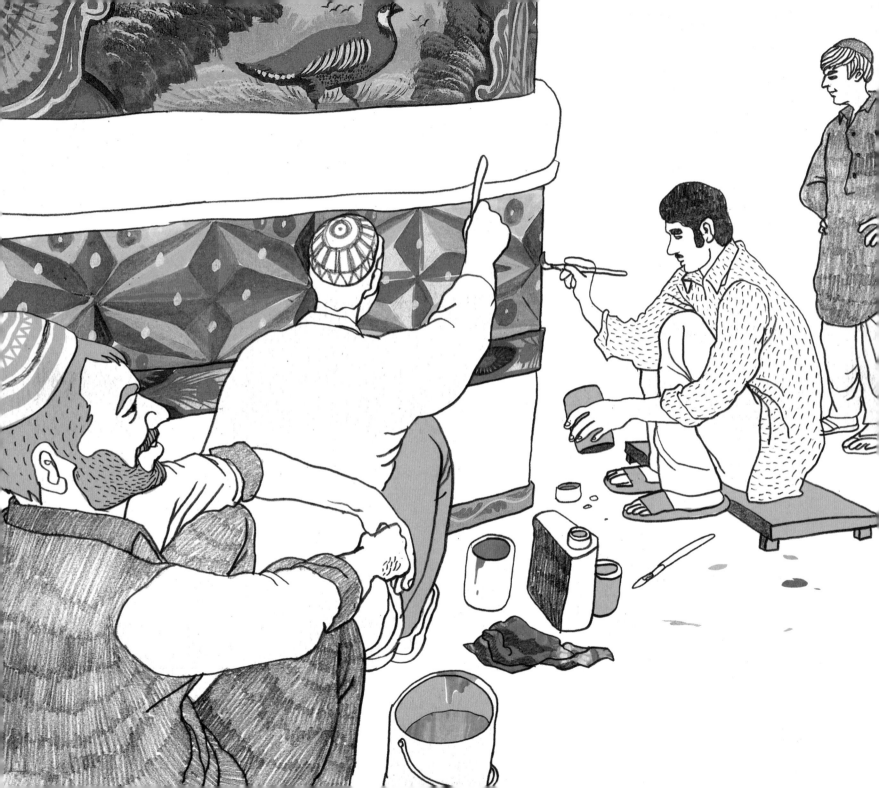

Learning to drive a truck is not different from learning to paint: for, here too, you learn everything or nothing. You're driver, cleander and mechanic rolled into one. If the truck breaks down on the highway, you've got to know basic fixing. Not that I can do it all the time. Sometimes you need to replace a part, and then I send the cleander to the nearest town with a mechanic's shed to fetch it.

I remember a driver who drove on the Grand Trunk Road with me. His family helped him in many ways. His sons became mechanics. Even his daughters assisted him by making the key chains with little bells and beads and decoration for adorning the front window of a truck.

I love to drive, and I am very possessive about driving my truck. The excitement of the road, more so, when you can actually choose the route you want to go on, as I have – that's something I won't trade with anyone or anything.

These days, I mostly like to drive on the Karakoram Highway.

This is the Pakistan-China road built by Pakistani and Chinese people. They call it 'Roof of the World'. It stands tall at 16,002 feet. I did not know that it was the highest paved road in the world – until an older driver told me and that's already 8 years ago. Before that I had only heard of the great Khunjerab Pass. You enter Pakistan from the China side through this Pass.

The Karakoram Highway starts from Kashgar in the Xinjiang province in China and goes right up to Abbottabad, a city named after Sir James Abbot, a white man, who loved to dress like an Afghan. He founded this city and even wrote a poem about it. Past Sir James' city, the road meets the Grand Trunk Road to Afghanistan in the north and further, as the crow flies, it goes on, all the way to Tajikistan.

When you are alone for hours and there is nothing in front of you except swirling low clouds and those tall mountains, who else can I turn to but God to feel safe? This is why many of our trucks have 'Mashallah' the name of God, or some such similar invocation, painted on them.

People inscribe other things as well on their trucks. The man whose trucks I drove for the first 15 years of my working life was a bit of a poet, and would get painters to paint in phrases and lines from his verse. They painted these beautifully, on the sides and rear.

I don't go in for all that. Apart from 'Mashallah' to express thankfulness and appreciation to God, the only other line of text I want put in is 'Pappu yaar tung na karr'. I'd like this written at the back of my truck. This phrase can mean many things, but basically it is for those who are behind me, all those truck and jeep drivers. All I am saying is 'Pappu, Man, don't hassle me!'

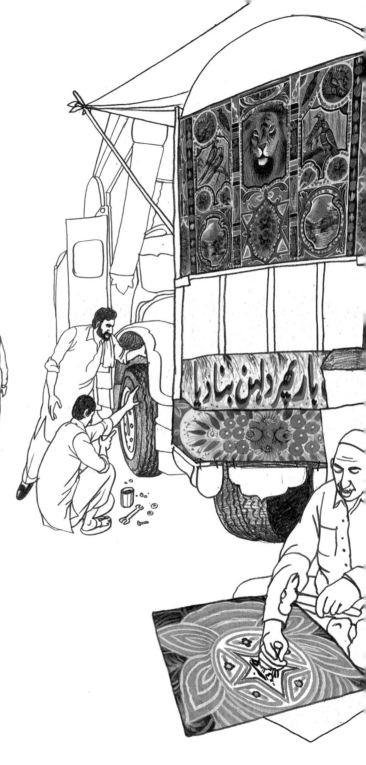

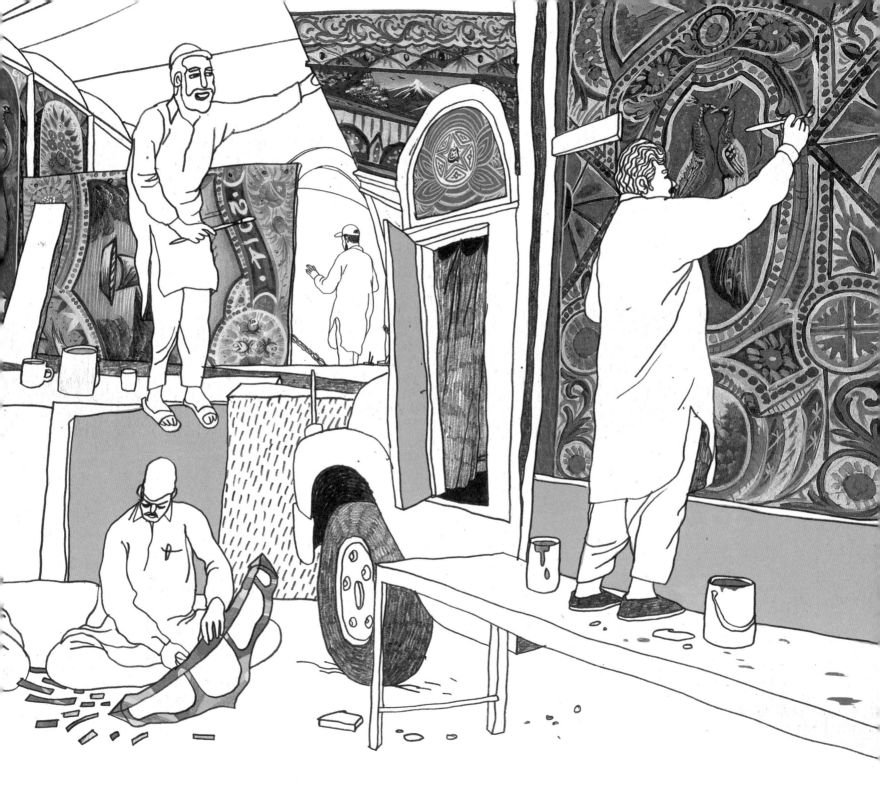

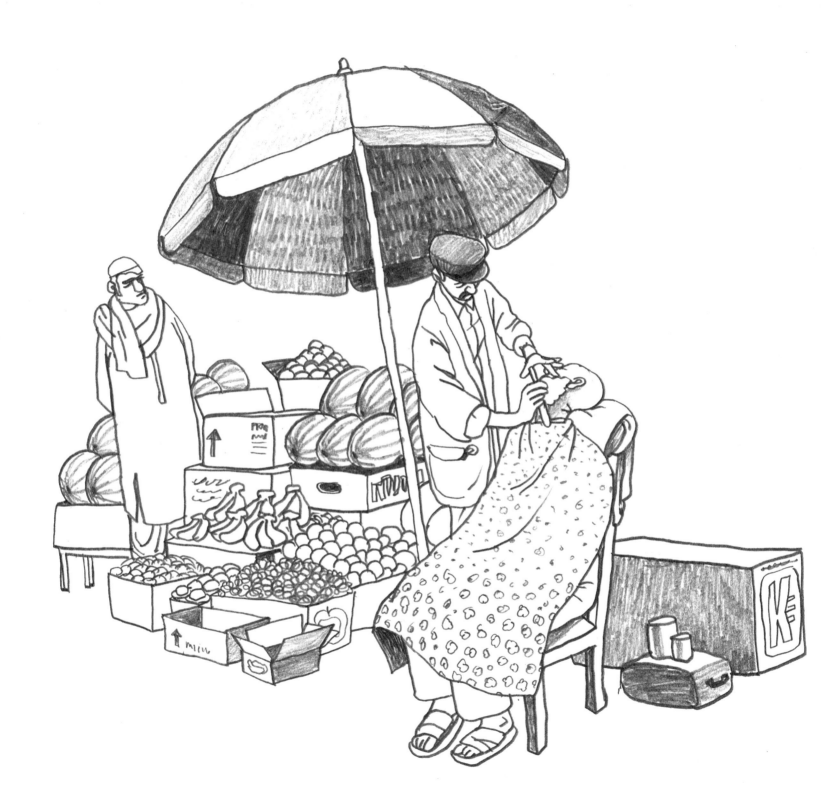

When I am on the Karakoram Highway, I carry freight to and from China: wheat, potatoes and wooden sleepers. My favourite goods are fruits that I take back to China: a truck full of fat, luscious green melons is a sight! The smell of fruit, the mixture of sights – these are invigorating and help me keep going and not get tired.

Ideally I'd like to stop every 3-4 hours and stretch my legs. But in the days gone by, I didn't always get to do that, for you couldn't afford to be late. If you were, the master would deduct money from my pay. Back then, I did not ever sleep properly. We'd stop at these hotels – nothing more than lay-bys – on the road. In the open were laid mattresses – those nice takhts – and round pillows and we'd loll there for a while, stretch our legs and get some shut-eye time. Sometimes, I got so tired that I even forgot my own name! A driver friend jokes to this day that once when I was woken up in my sleep and asked my name, I replied 'tyre' or 'fender' or some such thing!

At least now I am my own master. I do what I can and get some time to rest.

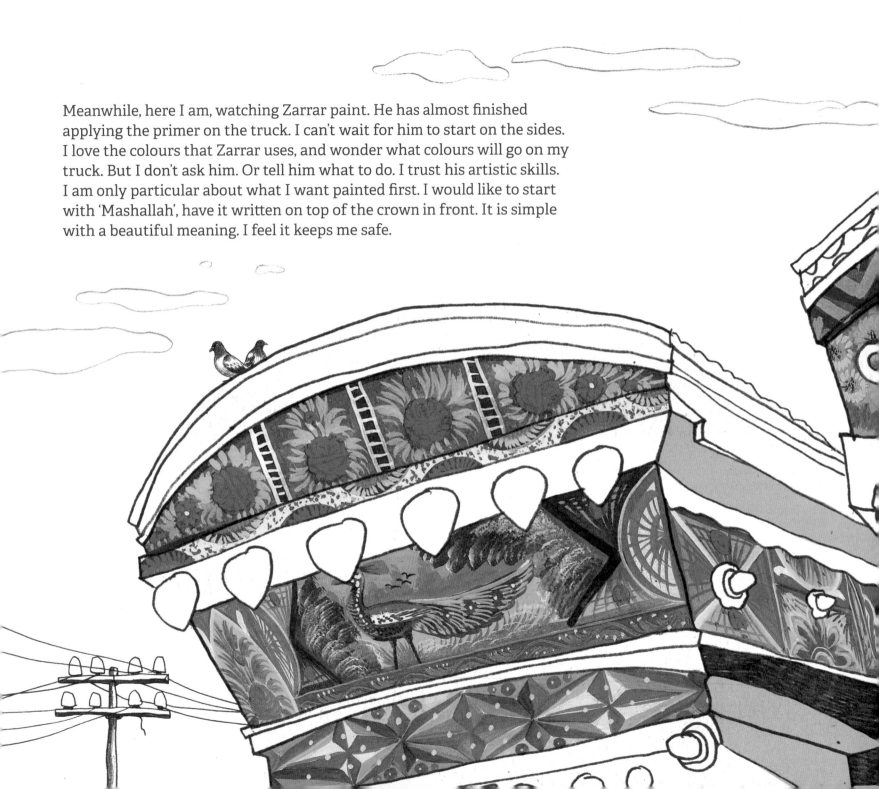

Meanwhile, here I am, watching Zarrar paint. He has almost finished applying the primer on the truck. I can't wait for him to start on the sides. I love the colours that Zarrar uses, and wonder what colours will go on my truck. But I don't ask him. Or tell him what to do. I trust his artistic skills. I am only particular about what I want painted first. I would like to start with 'Mashallah', have it written on top of the crown in front. It is simple with a beautiful meaning. I feel it keeps me safe.

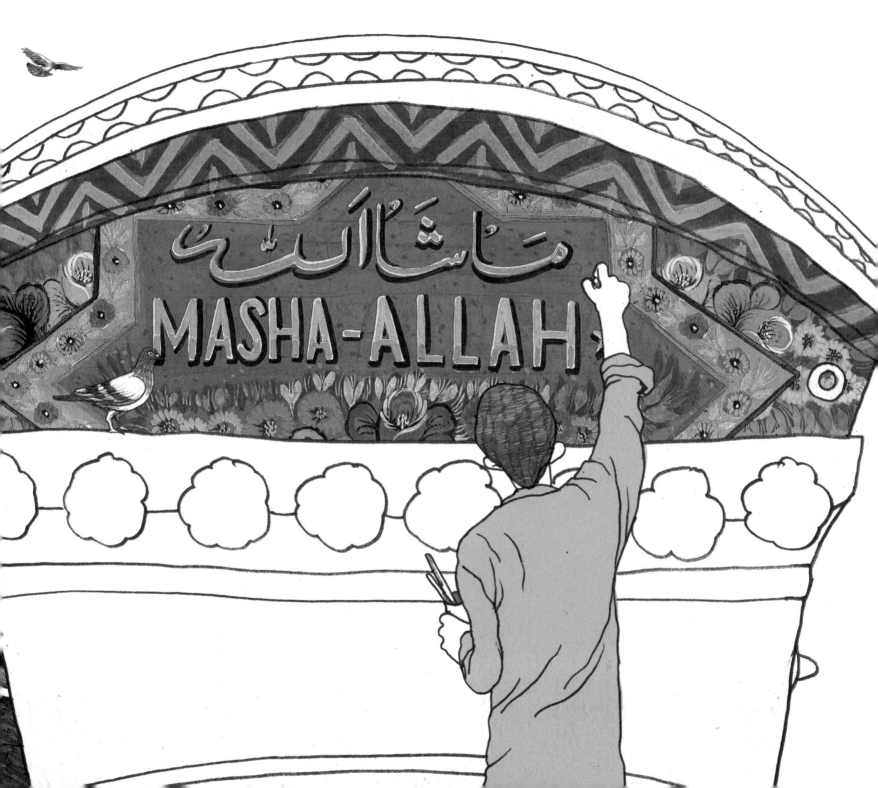

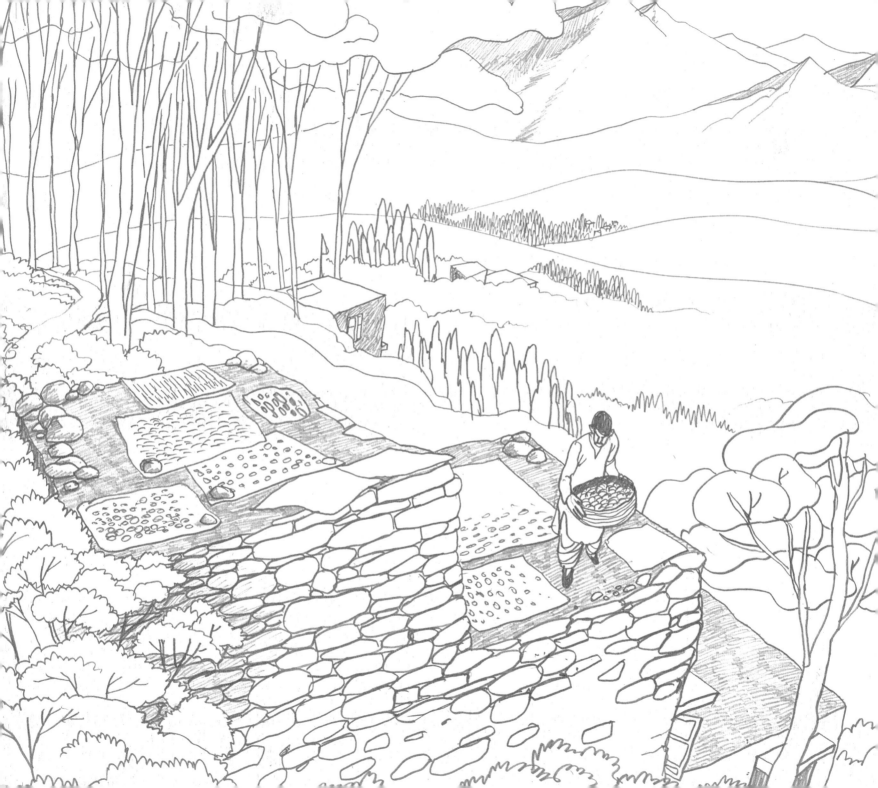

It's important you drive carefully, and mind other drivers on these mountain roads. You don't know what can go wrong. In 2010, a huge landslide breached parts of the mountain. It blocked the flow of the Hunza River – in the Gilgit area – and a huge stretch of the Karakoram highway was inundated. Worse, villages were flooded, and people died. The water that was blocked became a lake overnight and came to be known as Attabad Lake. The water in the lake kept rising with the melting glacier and for a while people couldn't move about easily, and children couldn't go to school. Now they have boats to ferry people, goods, vehicles, animals across the lake.

To this day, the highway remains cut and when we bring in goods from China, we reload them on these small boats and then bring them to trucks on the other side of the lake. From there, they are transported through the Hunza Valley.

Disasters apart, this is a beautiful part of the world. The magnificent Indus meets the Karakoram Highway at exactly the point where the Hindu Kush, the Himalaya and the Karakoram meet – now, that's a sight you live for. Or take the Nanga Parbat, the 9th highest peak in the world: on a clear day you can see it from the highway, in all its height and majesty. The mountains are rocky and dotted with different-coloured and shaped stones, some of them are very unusual. It is fun to have a collection of these stones. Peak and slope, rock and stone change colour every few kilometers. The road is so picturesque, and I don't get bored even though I have been on it for a very long time.

Zarrar is done with the crown.

Now, I wonder if I should get him to paint some of my favourite mountain creatures and fruits on the side panels. I dream of these creatures being part of my truck: the blue sheep of the valley, the ibex and a small bear. You do see them from time to time. What about a snow leopard, I wonder. Or my favourite fruits, apricots, plums, mulberries, grapes, walnuts, peaches, apples – many of which grow in the Hunza Valley.

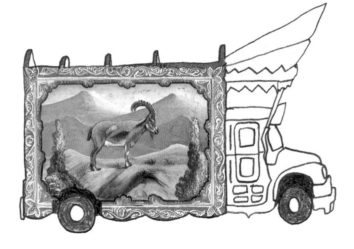

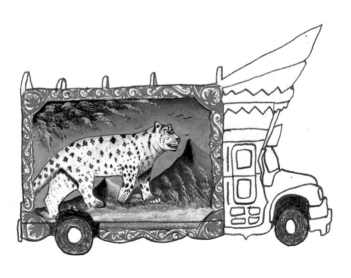

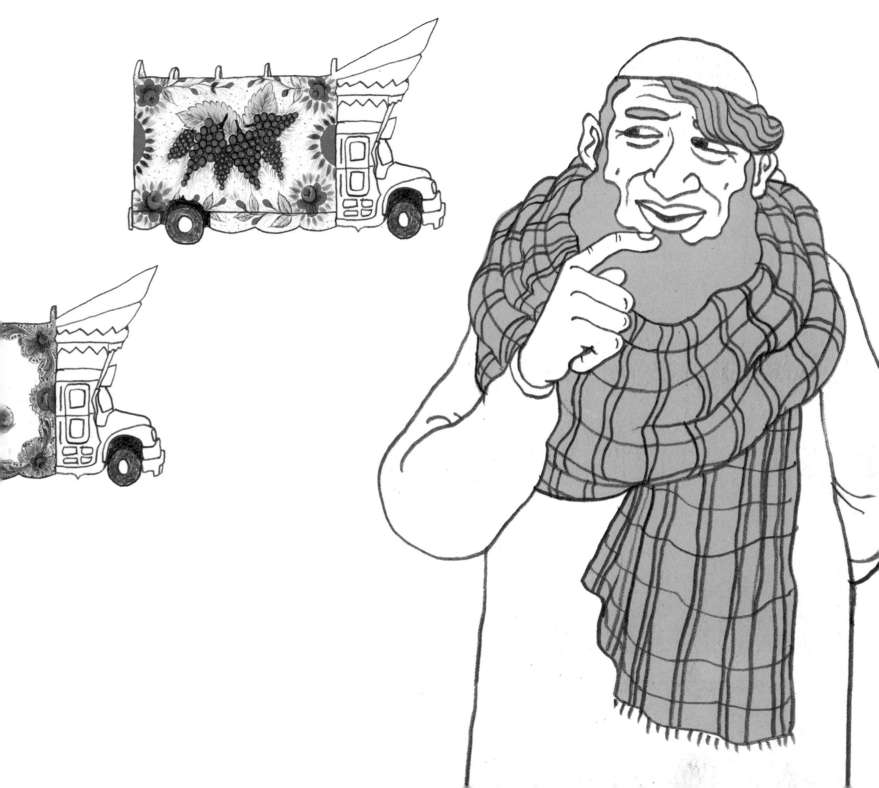

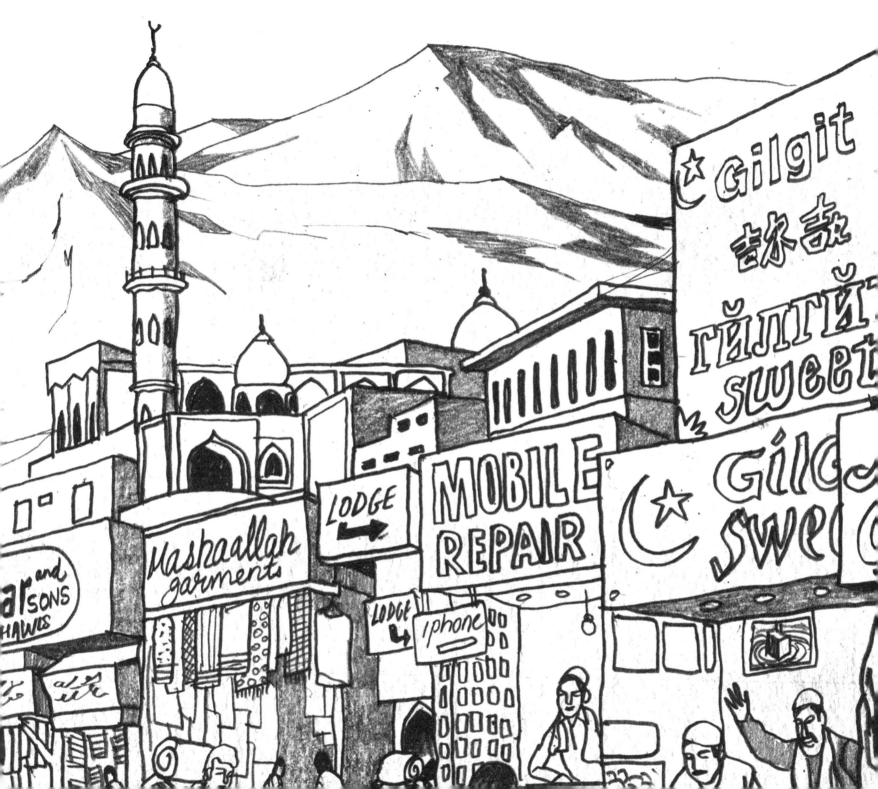

I sometimes think it's quite a miracle that fruits grow in these parts. But, then, today the harsh terrain of the Hunza Valley is richly irrigated. Water channels bring water from the waterfalls in the mountains. That's an impressive bit of engineering. If it was not for these channels nothing would survive, and you won't have the golden fields of corn, wheat, potatoes and fruit trees that you see now!

I love the valley, and always feel regret when I have to drive out of it. But then, when I get to Gilgit I feel happy again. Gilgit is a small town but it has an airport. I like the town's old forts and the stories people tell about them. One of the forts, I believe, was home to a fairy queen who lived in a crystal palace! Lots of tourists travel to Gilgit by air – but only if there are no clouds and it is safe for planes to land and takeoff. When there are no flights, tourists and villagers crowd our trucks.

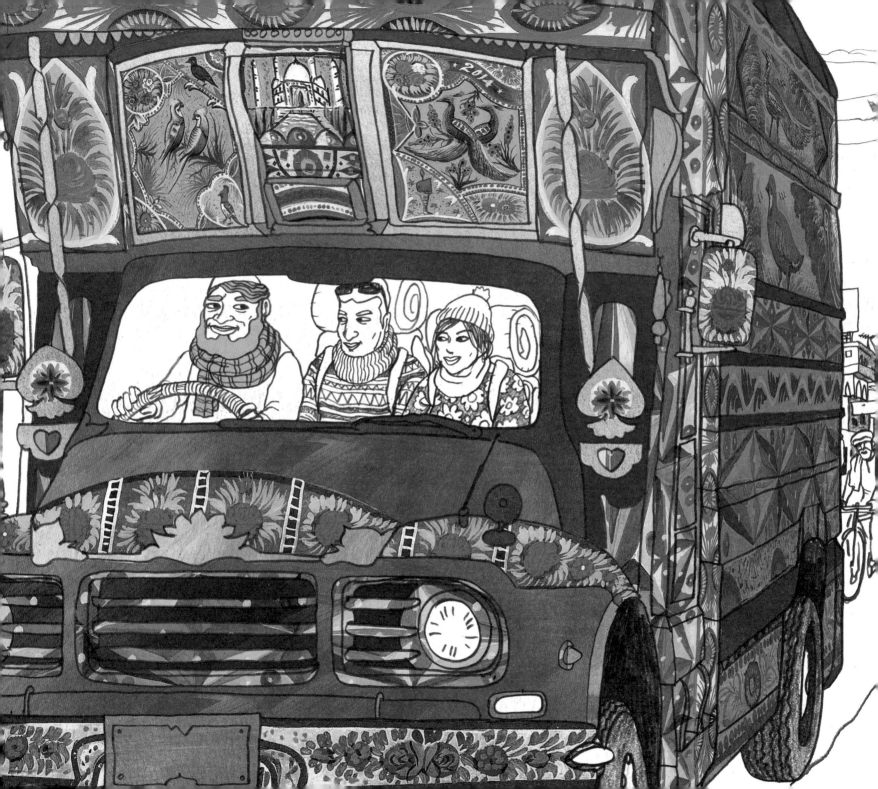

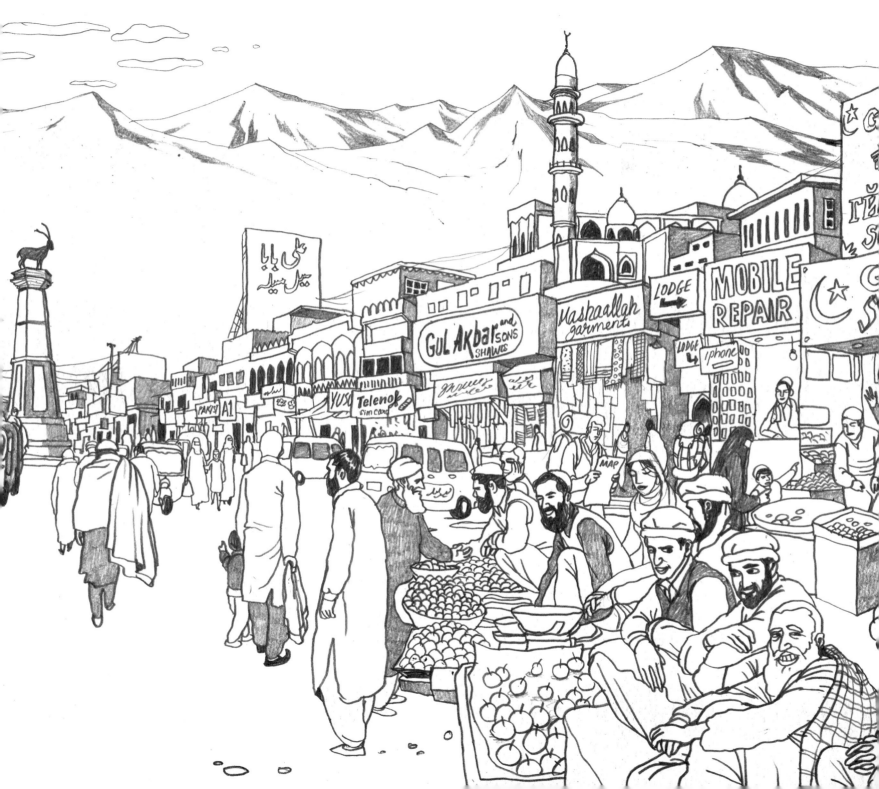

Today is my fourth day at the truck-yard in Taxila.

Zarrar has just told me that he will paint partridges and mountains on the sides – he is not sure about the bears, sheep, apricots or mulberries for that matter.

"How about a camel?" I joke. He shakes his head. I've told him that on no account is he to draw a snake. Once I found one of those creatures in my engine, and am not going to invite them in a second time.

Zarrar's going to get the wheels and the bumper decorated with reflector tape in the disco style. This is what I like about him: he takes charge of the truck, and not only because it fetches him money, but because he loves what he does. He gets quite lost while painting, or watching the sides of the truck being decorated with patterned reflector tape. Often his assistants have to remind him that he hasn't eaten.

Watching artists decorate and draw, I wonder what inspires them. Perhaps it's like what I feel when I drive slowly on some days, taking in the sights. I feel happy when I do, and get a sense of satisfaction.

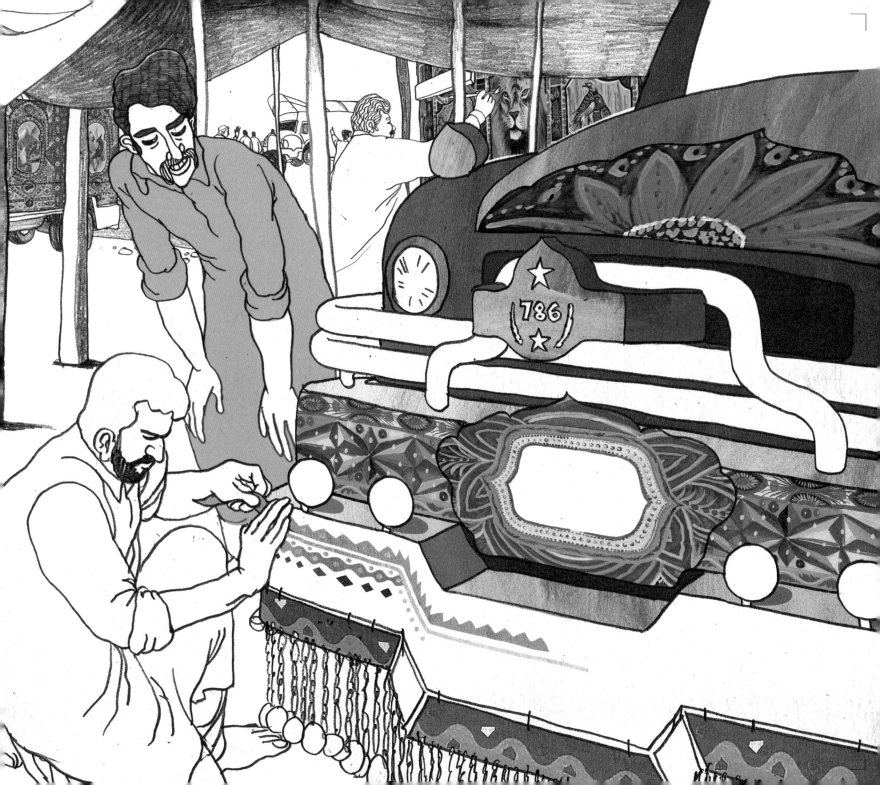

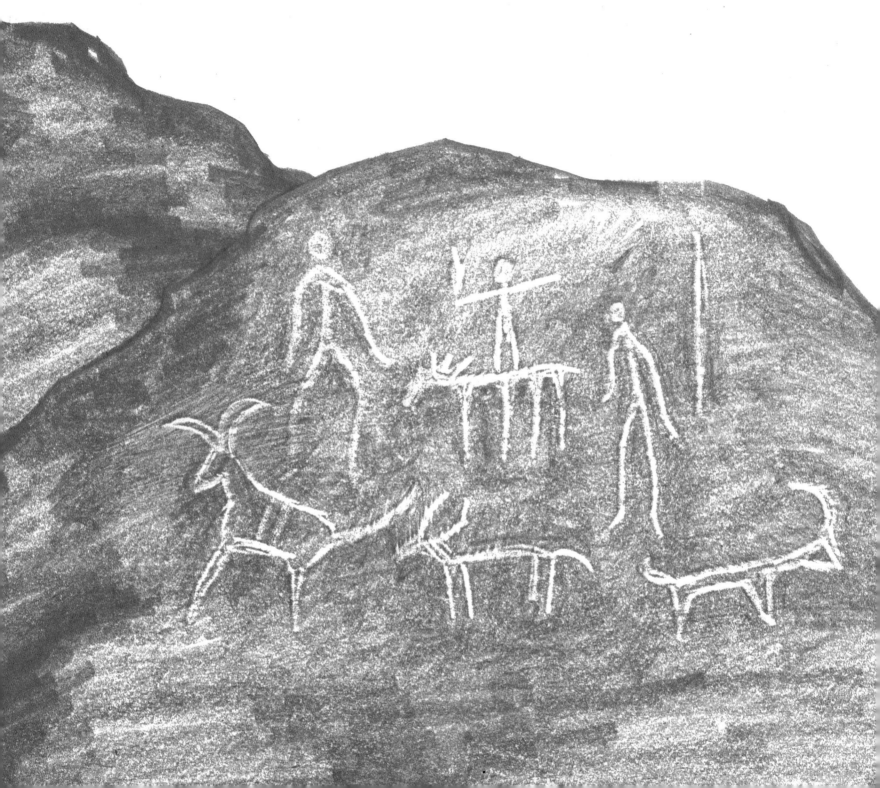

Gilgit is famous for its rock art. Once I gave a lift to a tourist guide after his flight from Gilgit was cancelled. He told me that people have drawn on rocks in the region for centuries. He said that he'd seen some rare drawings that are thousands of years old, on some of the rocky mountain sides. "These are drawings of human beings and animals but they are drawn in an unusual pattern. They are all drawn in triangular shapes and animals and humans are of the same size."

Some tourists know a lot about these mountains. It's from one of them that I learned that the Karakoram Highway is not only this new road. Once it was part of an old road, and traders, pilgrims, soldiers and entire armies used it, he said. Then it was known as the Silk Route, and ran from China through what is now India, Pakistan, Afghanistan all the way through Tajikistan, Uzbekistan... until it reached Turkey! There were no trucks in those days, and donkeys and camels carried people and goods for trading. These animals were decorated with tassels and bells, and fitted with embroidered saddles and carpets. Tents were also decorated on the insides with 'namdas', which were hand-woven rugs made of sheep wool and painted with vegetable dyes.

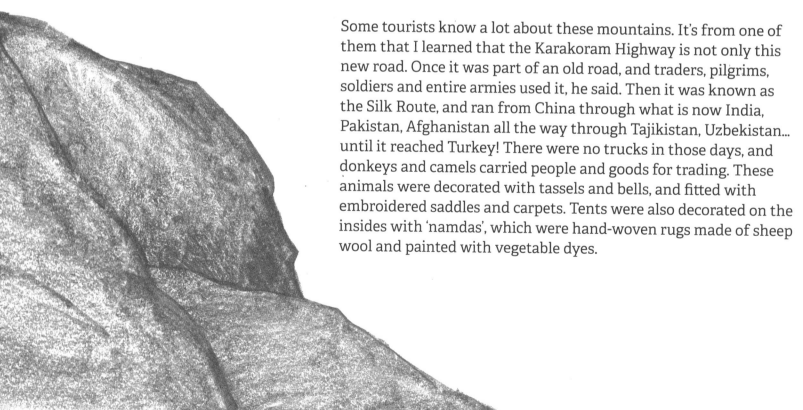

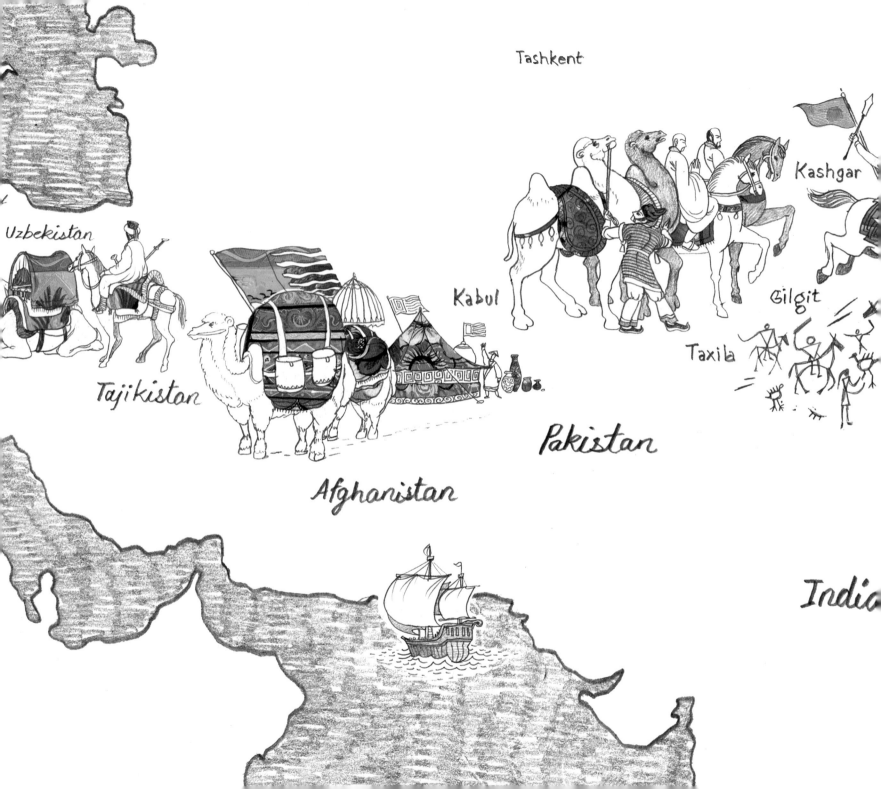

Tashkent

Kashgar

Uzbekistan

Kabul

Gilgit

Taxila

Tajikistan

Pakistan

Afghanistan

India

China

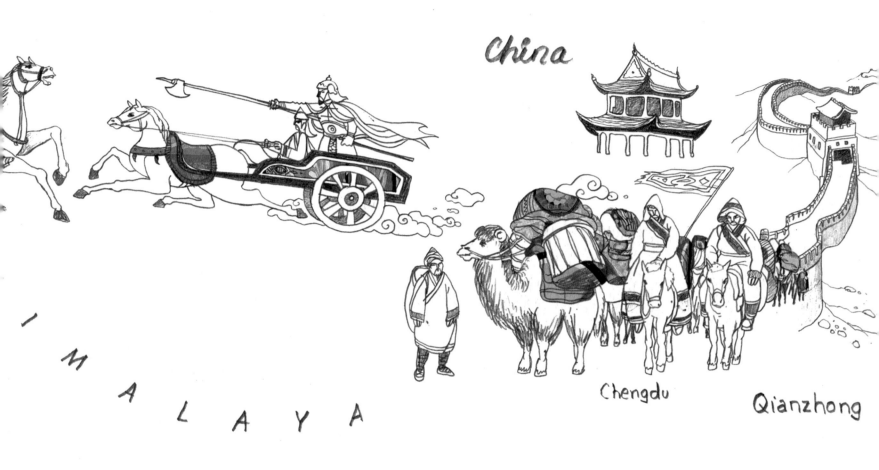

I M A L A Y A

Chengdu

Qianzhong

N

I'd like my cabin decorated, and must make sure that Zarrar remembers to do that. I'm thinking of re-fitting the cabin ceiling and seats – with multi-coloured velvet covers, complete with applique lace and gold braids. The rest of the cabin should match up to that.

I wonder if Zarrar wants to add decorations to the windshield. I should ask him. I see that he has finished the sides, and wheels. There's still a bit of work to be done around the headlights. I love the glow of trucks on the road, especially on misty nights. These are romantic nights, but the mist can be dangerous and drivers have to be very careful while driving on these winding roads.

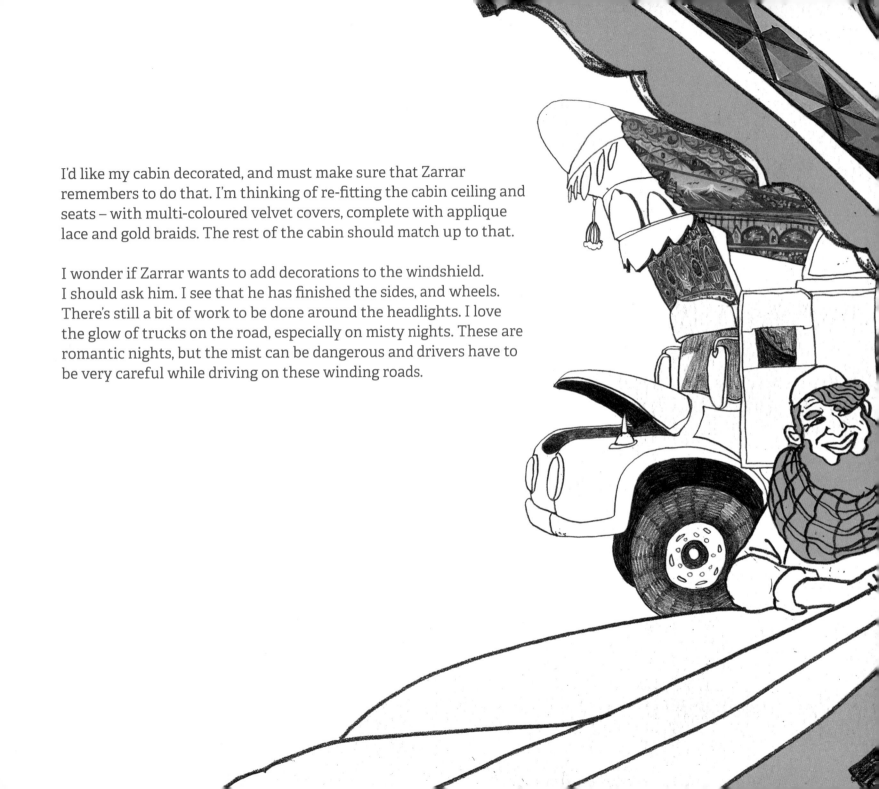

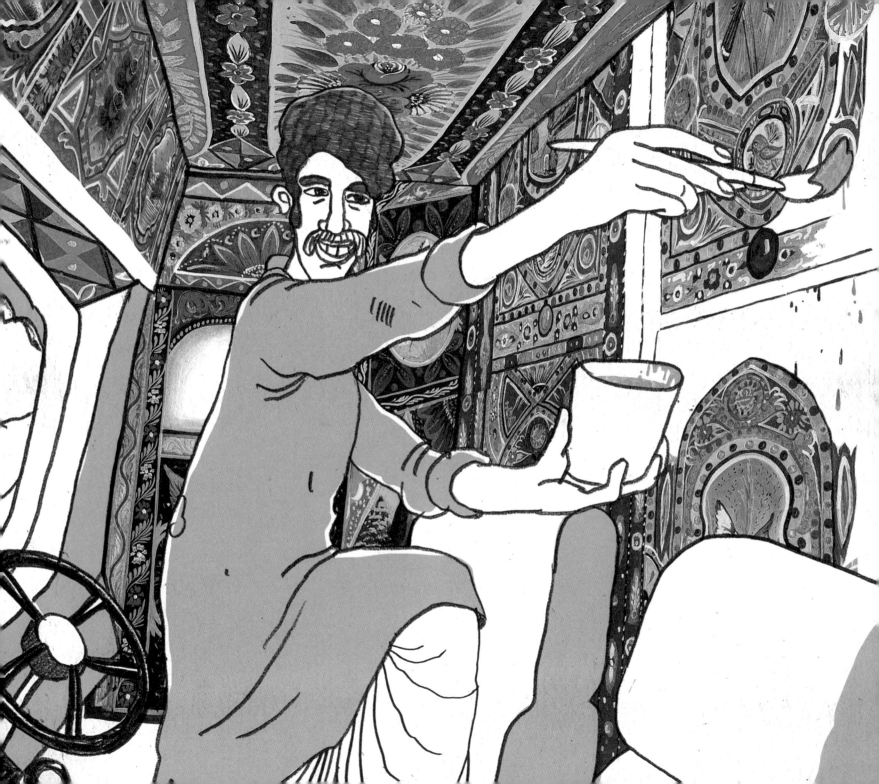

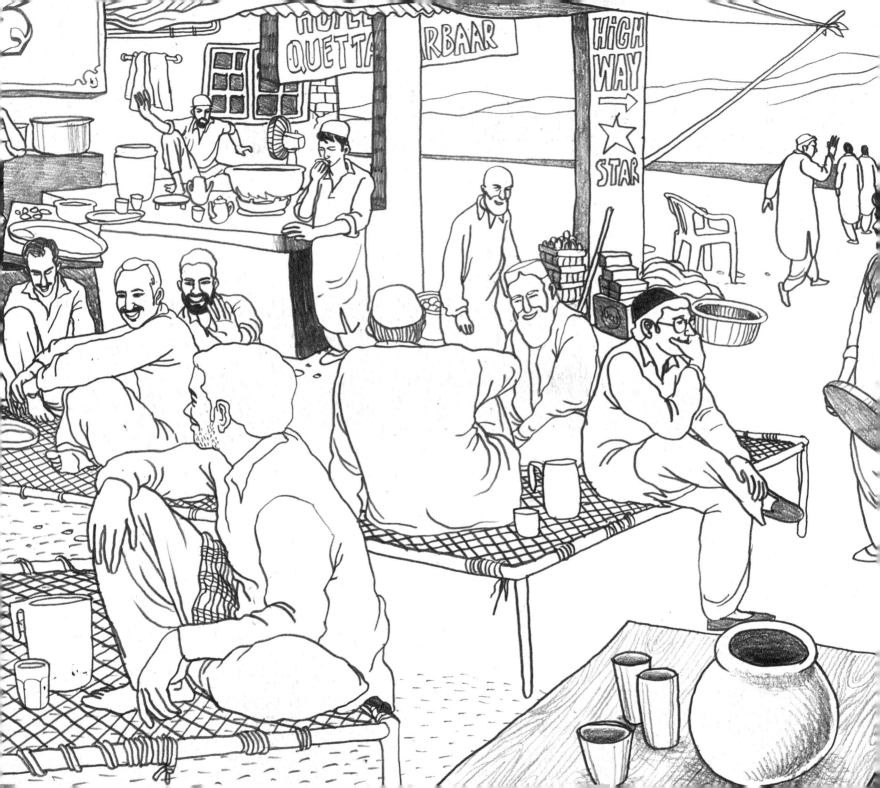

I once got my sons to go with me on the truck, just so to show them some of the marvellous sights I've seen on these roads. They were very excited, and wanted to go again and again, but how can they? They have to go to school. They also help their mother in the fields, with sowing and harvesting. Besides, they take the sheep and cows out to graze. Without the boys, she will not be able to do all that there is to be done, at home and in the fields.

My favourite dhaba, where I stop often for eating, is called the Quetta Darbaar Hotel. Some friends own it, and whenever I go there, I enjoy gossip and gup-shup with them and my fellow drivers. Some of them are like family now, and I can comfortably ask for credit.

But I miss the warmth of my family kitchen and ideally would like my family around me. I try not to worry about my wife and sons when on the road.

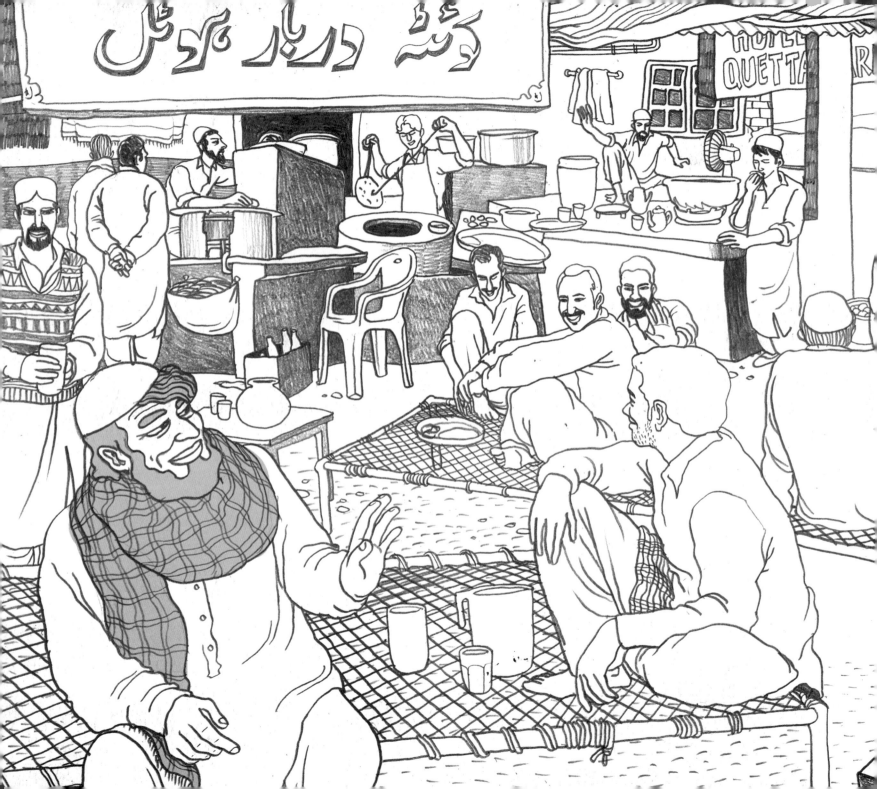

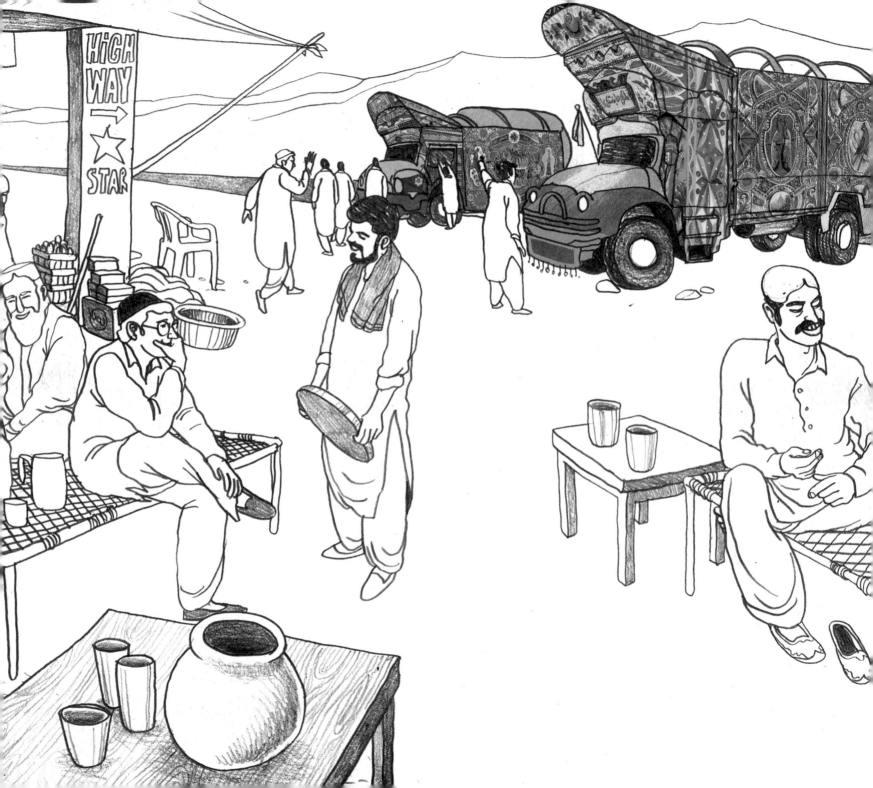

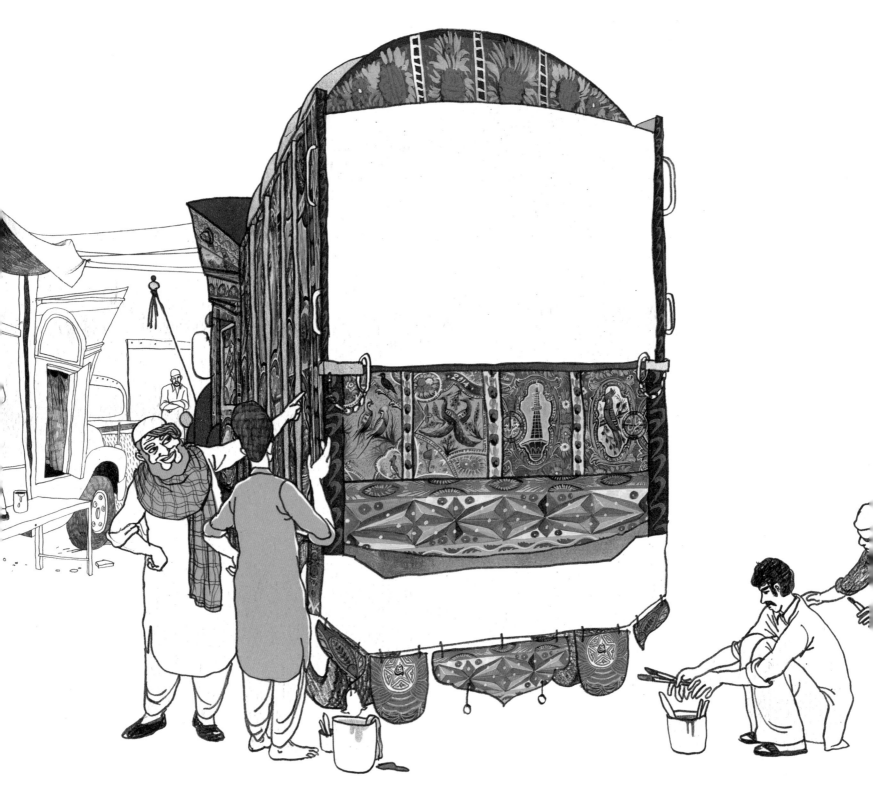

I guess though that my truck feels like home.

I listen to music I like while I drive, and I feel quite at peace most of the time. When it's decorated fully, I will feel proud to drive this beauty on the road.

Zarrar has finished with the cabin interior and the glittery 'chamak patti' decorations are also done. Now, only the large rear painting is left. My wife said that she'd like to have the portrait of her favourite singer, 'the Queen of the Road' painted on the rear. My eldest son insists I paint his all-time cricket hero, while my younger son wants a giant airplane drawn! I am not sure. Whatever picture I choose to put at the back, it ought not to disturb me. I want to be able to sleep well in my truck and if the picture bothers me, I'll have bad dreams!

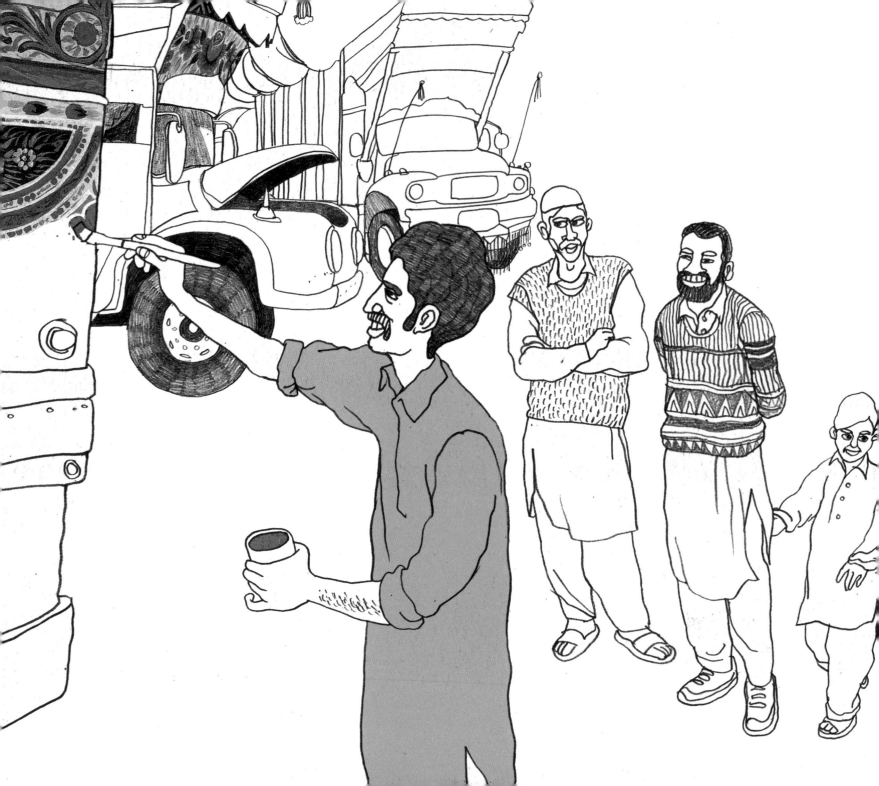

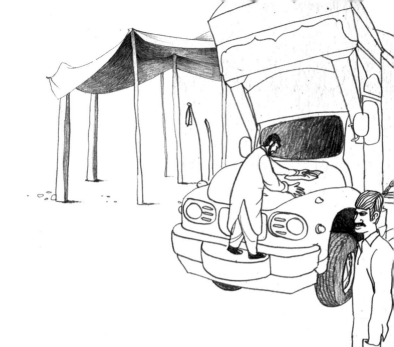

Zarrar has come a long way too.

When he was an assistant, he was not paid or anything – just like Ajab, my other painter friend. Zarrar first worked for his uncle who looked after him. He was a kind man and as soon as Zarrar's hand was steady, he got him to draw outlines of images. I remember his first attempt: he had to use a pencil to sketch the outline of a peacock. His hand shook nervously that day. When his uncle got old, he sold his business to another man. That man was a kind employer, and he paid Zarrar for what he did – not much, but it was not bad either. Sadly, some employers are neither kind nor fair. They pay their artists very little and make them work long hours. Drawing and painting are not easy. Like metal work, which involves cutting, welding and pasting, they also require concentration and effort.

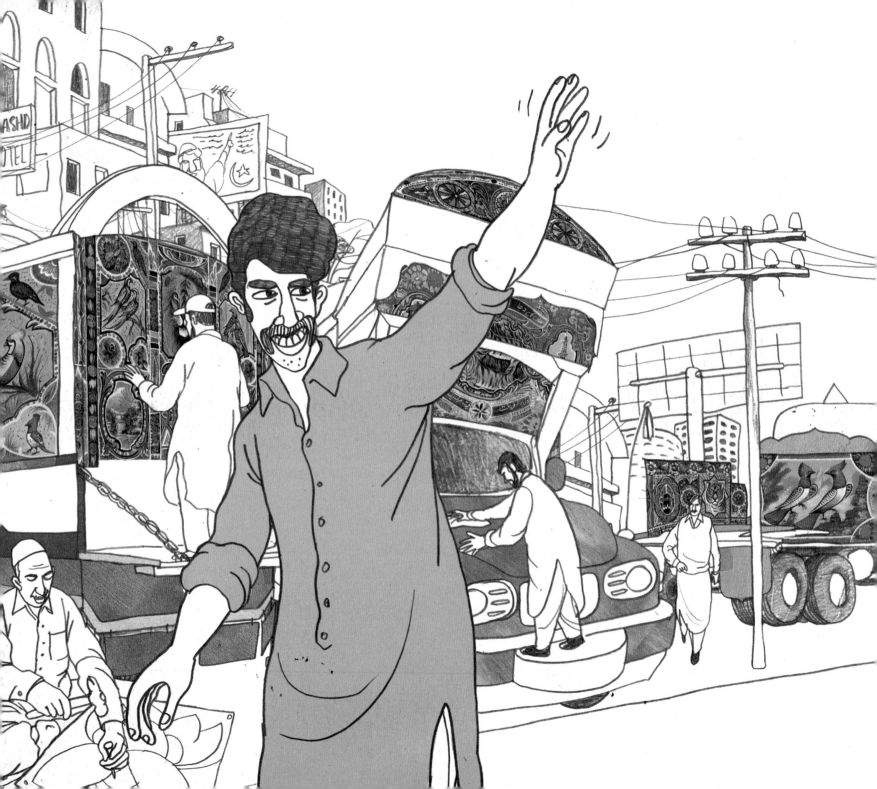

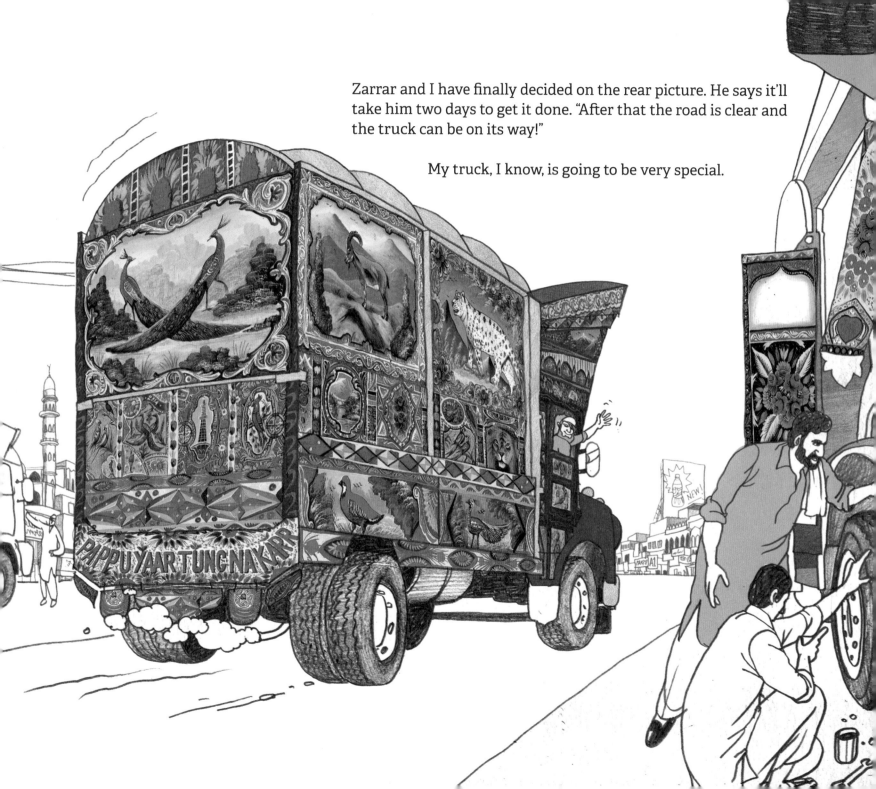

Zarrar and I have finally decided on the rear picture. He says it'll take him two days to get it done. "After that the road is clear and the truck can be on its way!"

My truck, I know, is going to be very special.

The Making of the Book

This Truck has Got to be Special is a tribute to a very special form of popular art: the imagination, artisanship, design, and labour that goes into decorating trucks in Pakistan. The making of this book was an ambitious project, involving a five-cornered conversation between us, the author Anjum Rana (who works with the truck artists Hakeem Nawaz and Amer Khan), the Mumbai-based artist and designer Sameer Kulavoor, and graphic designer Rathna Ramanathan, who lives in London.

So how did the idea for this involved project come about? We've always been drawn to different forms of everyday art, and painted Pakistani trucks, in all their resplendent and stately beauty, intrigued us. They appeared all the more special, given their everyday context: they are driven along some of the most difficult mountainous terrain in the world, in all kinds of extreme weather. The art they feature is remarkable therefore, for its spirit of celebrating beauty and bringing a sense of wonder into an otherwise tough working life. So, when we had an opportunity to work with truck artists, we were delighted.

What is Truck Art?

Truck art is found in other countries as well – Indonesia, Afghanistan, The Philippines and in parts of South America. In Pakistan, though, vehicle decoration has acquired an iconic status – and is the hub of an entire craft economy devoted to it. Trucks are painted according to their owners' wishes, to add to their prestige and status – though in some cases, the details of the decoration can be left to the driver's discretion. Various kinds of artisans work on trucks: carpenters, metal workers, and painters – and depending on what is affordable, owners go in for less or more decoration.

There are different styles of truck art in Pakistan, each associated with particular cities, and some styles set greater store by metal work than others. But there are common features to this art, which give it a very distinctive aesthetic. Truck art combines calligraphy, decorative metal work, and the art of the bazaar or market, which specialises in portraits, landscapes and iconic representations of birds and animals. Bazaar imagery and rendering are bold and graphic, usually in fluorescent colours. Metal work is subtler, with some features akin to miniature painting, especially in some of the intricate detailing. While some of this singular work is given over to specialised artisans, calligraphy is usually added by the main painter of the truck.

The art covers the entire surface of the vehicle: the crown – or roof-like structure above the windshield, the bonnet, the fender, the back and sides, the cabin space, and even the wheels. The crown is usually decorated with religious messages or paintings of Islamic holy places. The sides feature landscapes, animals, birds, and talismanic elements that help ward off bad luck. Sides can be additionally decorated with reflector tape and metal plates – including metal-cutouts of embellished birds and animals. The cabin is dressed up with silk and satin upholstery, painted ceilings, mirrors and pompoms. The back of the truck usually carries a single image – of a

bird or an animal, a political figure, a favourite musician or sportsperson. The lower parts of the truck, including wheels, are beautified with metal rings, discs, chains and patterned reflector tape. Artists and artisans learn on the job – there are long periods of apprenticeship which they have to go through before they can set up on their own. The work is carried out in regular truck-yards, to the smells and sounds of the automobile world.

The Book

 This is the world that the book tries to capture. We first met the author Anjum Rana some years ago, when she came to our city as part of an international craft fair. Her stall featured objects decorated by Pakistani truck artists, with whom she had been working for several years. Anjum lives in Pakistan, and truck art is something of a passion for her.

When we began talking to her about doing a book on the form, we realised that we needed to focus not just on the art, but also on the world of truck artists – and the drivers for whom these beautiful vehicles were a kind of home away from home. It was clear to us that truck art was part of a way of life that included all these people, and of an entire economy and web of relationships that were absolutely necessary for the movement of goods in this challenging terrain. The story of travel, commerce and adventure – part of everyday life for the truckers – also reminded us of older histories and geographies that linked this part of the world. It seemed important now to remember these other ways of being global.

To put this complex story together, Anjum Rana interviewed truck drivers, owners and artists about their lives and work. We worked on the narrative with her, and once this was in place, began to think about the greater challenge of creating a visual narrative along with the artists Anjum worked with. Truck artists are best at painting trucks – or other large, three-dimensional surfaces. While they could translate some of these designs on to paper, we still needed another interface: an artist or designer who would conceptualise the story into narrative images – and provide the truck artists with templates which they could fill with their own imagery. We decided to work with Sameer Kulavoor, a Mumbai-based artist and designer, who is particularly ardent about street life in the Indian subcontinent. This was just the kind of project he enjoyed working on, and he came up with a visual concept that told the story in black and white images, featuring the truck as the only burst of colour.

It was a complicated process: he sent the truck artists (through Anjum) outlines of various truck parts, which they then filled in the way they wanted. We made our selection from the choices they sent, and they went on to complete the images. Sameer then re-worked these painted truck images into his illustrations. But the project was still not finished. It required another graphic designer – Rathna Ramanathan – to put together text and images in a form that communicates in the way this book does. It has taken three years to complete this challenging five-cornered dialogue, one of the longest projects we've worked on, but we think it's been worth the time and effort.

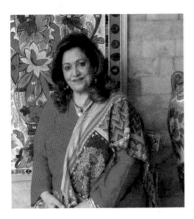

Anjum Rana is a Pakistan-based interior designer who works with truck artists on furniture, walls, household objects as well as objects d'art. Through the initiative Tribal Truck Art, she has helped develop opportunities and contexts for truck artists to practise their craft in sustainable ways. She is committed to bringing this art into mainstream cultural life and give it the recognition that it so richly deserves. Anjum Rana is a recipient of the UNESCO Seal of Excellence in Handicrafts Award in 2008. (www.tribaltruckart.net)

Hakeem Nawaz and Amer Khan are truck artists who work closely with Anjum Rana. They were trained from their early teen years by elders in their families, and today are acknowledged masters of the art form. In the art projects they undertake with Anjum, they have retained their original brush-strokes, but have also grown adept at drawing on smaller surfaces as larger ones.

Sameer Kulavoor lives in Mumbai, India. His work lies in the intersection of graphic design, contemporary illustration and art – and he has his own studio, Bombay Duck Designs. He publishes artbooks and zines, which feature characteristic mannerisms and images of urban life, design and culture. (www.bombayduckdesigns.com)

This Truck has Got to be Special
Copyright ©2016 Tara Books Pvt. Ltd.

For the text: Anjum Rana
For illustration design: Sameer Kulavoor
For the truck art: Hakeem Nawaz, Amer Khan

For this edition:
Tara Books Pvt. Ltd., India, tarabooks.com
and Tara Publishing Ltd., tarabooks.com/uk

Design: Rathna Ramanathan
Production: C. Arumugam
Printed in India by Multivista Global Private Limited.

ISBN: 978-93-83145-42-3

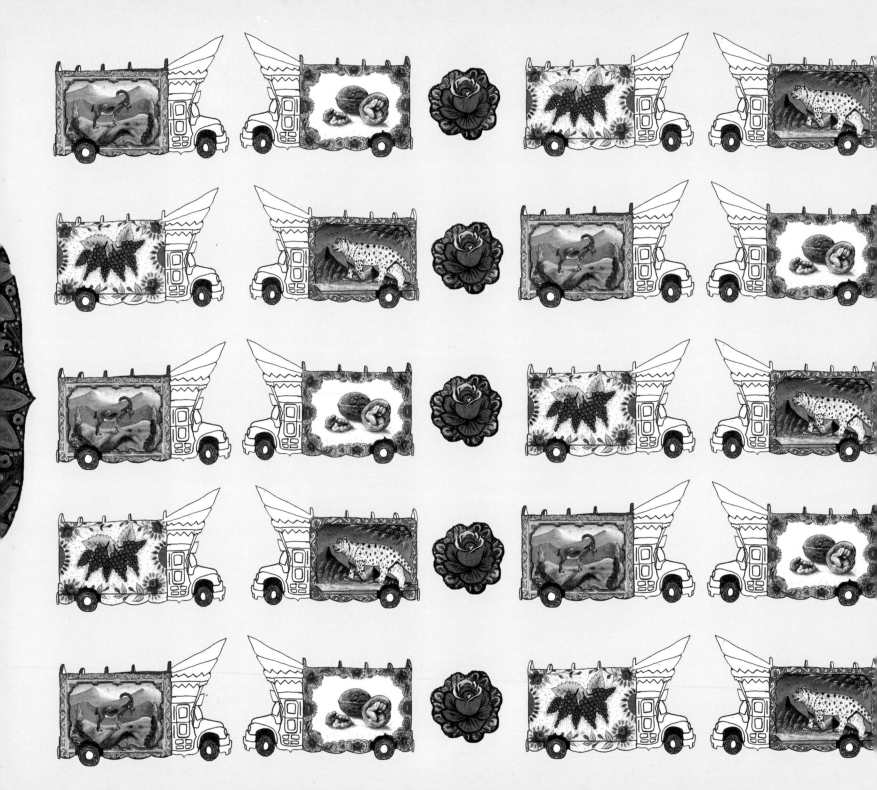